*Images of Modern America*

# SKI PATROL IN COLORADO

*Images of Modern America*

# SKI PATROL IN COLORADO

JOHN B. CAMERON
AND ERIC D. MILLER

ARCADIA
PUBLISHING

Published by Arcadia Publishing
Charleston, South Carolina

Library of Congress Control Number: 2018942671

For all general information, please contact Arcadia Publishing:
Telephone 843-853-2070
Fax 843-853-0044
E-mail sales@arcadiapublishing.com
For customer service and orders:
Toll-Free 1-888-313-2665

Visit us on the Internet at www.arcadiapublishing.com

*This book is dedicated to the hardworking
women and men of the ski patrol.*

# CONTENTS

# ACKNOWLEDGMENTS

*Ski Patrol in Colorado* would not be possible without the generous contributions of many individuals, organizations, ski areas, and museums that graciously shared their time, stories, and photographs for this book.

Deserving of special thanks are Scott Pressly, Caswell Rico-Silver, Rich Moorhead, Zach Moore, Miles Porter V, Mark Walker, and the Friends of Monarch Ski Patrol for their encouragement and willingness to help get this project started. They provided not only photographs but helped identify many of the people, places, and locations therein. Special thanks are in order for Tony Cammarata of Arapahoe Basin Ski Patrol and Adrienne Saia of A-Basin who went out of their way to provide both historic and contemporary photographs of Arapahoe Basin Ski Patrol. I am grateful to all the members of the Arapahoe Basin Ski Patrol for their encouragement and motivation during the process of writing and editing this collection.

Unless otherwise noted, the images in this book are from the author's collection. Additional images appear courtesy of Vail Resorts photograph archive, Monarch Mountain, National Ski Patrol (NSP), Aspen Historical Society, Tread of Pioneers Museum, the Colorado Snowsports Museum and Hall of Fame in Vail, Matt Krane, Deborah Davies, Wolf Creek Ski Area, Purgatory Resort, Eric Miller, Arapahoe Basin Ski Patrol, or Telluride Ski Resort.

I would like to especially thank Deborah Davies for sharing her photographs of Monarch Mountain and stories of Conquistador Ski Area, Jordan Halter for providing generous access to Vail Resorts photograph archives, and Candace Horgan of the National Ski Patrol for her help, research, and access to the NSP photograph archives.

Also, I am grateful that Matt Krane generously shared his personal collection of slides from Breckenridge Ski Resort.

This book would not have been possible without the historical societies and organizations around Colorado that work to preserve mountain culture and history. The Colorado Snowsports Museum and Hall of Fame in Vail, Aspen Historical Society, and the Tread of Pioneers Museum in Steamboat Springs all provided access to photographs.

I would like to thank Liz Gurley and the rest of the editorial staff at Arcadia Publishing for their guidance and expertise.

Thanks to Eric Miller, whose vision was solely responsible for initiating this project. Special thanks for support from both friends and family including Ryan, Garrett, Benjamin, and Haley Rush-Miller; Erin Miller Hughes; David and Joretta Miller; Hannah Skaggs Rush-Miller; and Renee Rush-Miller.

Special thanks to Keith Rush, Art Evans, Geoff Knechtel, Casey Shifflet, Nick Shifflet, Phyllis O'Grady, Glen Plake, Warren Miller, Chris Anthony, Loren McQueen, Jack Cameron, and Tammy Cameron.

Lastly, I am especially grateful for the unwavering love and patience of my wife, Julie Anderson, and my kids Jackson and Sierra.

—John Cameron

# INTRODUCTION

This book is about the thousands of men and women in Colorado who work to ensure the safety of skiers and snowboarders and other guests at Colorado ski areas. The work of a patroller is nuanced, demanding, and often goes unseen. They arrive around sunrise as the first ones on the mountain and are the last ones off.

Patrollers in Colorado arrive from many directions. Some come with college degrees, abandoning one direction to find themselves fully committing to a life orchestrated by the seasons. They are all professionals.

On the mountain, they are lifesavers. The iconic white cross emblazoned on their worn uniform jackets distinguish them from others on the mountain.

They are trained to the same high standards of emergency medical responders on city streets and can provide that care anywhere on the mountain regardless of terrain or weather.

Patrollers are also ambassadors of the mountain lifestyle. They ski more than almost anyone else during the winter, beginning when there is just barely enough snow to cover the rocks and on through the deepest snowstorms. Ski patrollers in Colorado are frequently in avalanche terrain. The most dangerous part of the job requires skiing onto slopes to dislodge avalanches while carrying explosives intended to be ignited by hand and used to dislodge even bigger avalanches. They move together in small groups and watch out for each other. For that reason, patrollers are a close-knit group.

Patrol headquarters and high mountain outposts where they stop to dry their gloves and slurp bad coffee become steeped with tradition. Often, the walls are covered with photographs, and stories are told and retold regardless of how many times they have been shared.

Stories of ski patrolling in Colorado go back many decades, to when the modern ski industry was just in its infancy. Small alpine ski hills with simple rope tows began to open for business around the state. Howelson Hill near Steamboat Springs, the oldest continuously operated ski area in Colorado, opened in 1914 as a ski-jumping area. Following closely behind were Loveland Ski Area, which opened in 1936, Wolf Creek Ski Area in 1938, and Monarch Mountain in 1939.

The years after World War II saw a boom in recreational skiing. As the industry grew, skiers were offered more services like new lifts and base area amenities. With an increase in visitors came an increased need to be able to respond in case of an emergency.

Since the early days of volunteer patrols, the job of ski patrolling has become ever more demanding as it has moved toward a professional position.

An experienced ski patroller is certified in emergency medicine, avalanche rescue, and weather forecasting; competent in high-angle rescue and technical rope rigging; capable of making repairs to equipment; an expert skier; trained in guest services; able to conduct accident investigations; and may be a staff trainer, a dog handler, and dispatcher all in the same day.

Over the years, as technology and ski areas have changed, ski patrol organizations have adapted but have been unwavering in their dedication to service and safety.

# One

# NATIONAL SKI PATROL AND THE 10TH MOUNTAIN DIVISION

Ski patrolling in Colorado had its beginning shortly before World War II, when recreational skiing enjoyed a surge in interest around the United States following the 1932 Winter Olympics in Lake Placid, New York. Small ski hills began to spring up around the country, including in Colorado.

Patrols had already begun to serve local hills when a need for a national standard of mountain rescue became apparent. In 1938, a Vermont ski patroller named Charles "Minnie" Dole established the National Ski Patrol, which was dedicated to service and safety in the mountains.

Shortly after establishing the NSP, the nation's attention turned to the war, and in an unprecedented move by the US military, Dole, a civilian, was tasked with recruiting members for a specialized mountain warfare unit called the 10th Mountain Division. Based on his recommendation, the most qualified candidates selected from ski racers, alpinists, Olympians, coaches, and athletes were sent to Camp Hale near Leadville, Colorado.

There, the "Mountain Troops" trained at high altitude, where they became proficient in technical winter travel, survival, and combat.

After the war, many members of the 10th Mountain Division returned home and to the mountains they had become accustomed to. Nearly 60 ski areas around the United States were founded or otherwise established by members of the Army's specialized unit, including many notable resorts in Colorado still operating today.

From plotting new ski areas to serving as the first patrollers, the National Ski Patrol and 10th Mountain Division ushered in modern ski patrolling that became common across Colorado.

**WINTER SOLDIERS.** Members of the 10th Mountain Division ski uphill along the Continental Divide. The first soldiers who would come to form the specialized unit began to arrive at Camp Hale near Tennessee Pass in the fall of 1942. There, they trained in skiing, winter survival, and combat techniques specific to mountainous terrain. Many members were recruited specifically for their skiing ability. Upon their return, members like Laurence "Larry" Jump, co-founder of Arapahoe Basin Ski Area, went on to play a pivotal role in the growing postwar ski industry. (Courtesy of National Ski Patrol.)

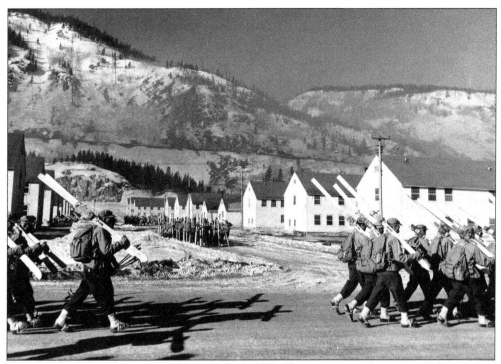

CAMP HALE, 1942. During World War II, the US War Department took an unprecedented step by authorizing Charles "Minnie" Dole, the founder of the National Ski Patrol, to recruit soldiers for the Army's 10th Mountain Division. Dole contacted each of the 93 NSP chapters at the time in search of anyone with relevant mountain experience. Each eligible soldier was also required to submit three letters of recommendation substantiating their skiing ability. (Courtesy of National Ski Patrol.)

WINTER TRAINING. Members of the 10th Mountain Division trained in Colorado from 1942 to 1944. The mountains along the Continental Divide prepared soldiers for combat in the Italian Alps during World War II. (Courtesy of Vail Resorts.)

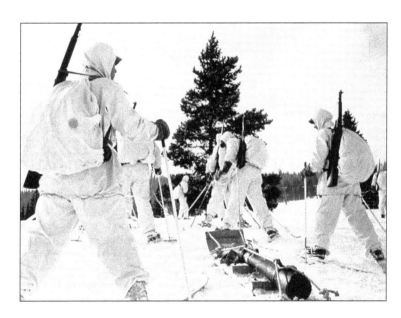

**GEORGE F. WESSON JR.** George F. Wesson Jr. holds his skis on the Continental Divide as a member of the 10th Mountain Division at Camp Hale, where he served from December 1942 to June 1944. Wesson was born on July 4, 1921, in Worcester, Massachusetts, and began skiing at a young age. He became a member of the National Ski Patrol in 1938, and like many men his age, joined the military during World War II. At his request, he joined the mountain troops stationed near Leadville, where he trained and taught skiing. He was discharged from the military after being partially buried and severely injured in an avalanche during a training operation. After 26 weeks of hospital recovery, he returned to skiing and continued to play a pivotal role as a ski patroller in the growing postwar ski industry. After over 70 years as a member of the National Ski Patrol, Wesson died in Rutland, Vermont, on September 6, 2010, at the age of 89. (Courtesy of National Ski Patrol.)

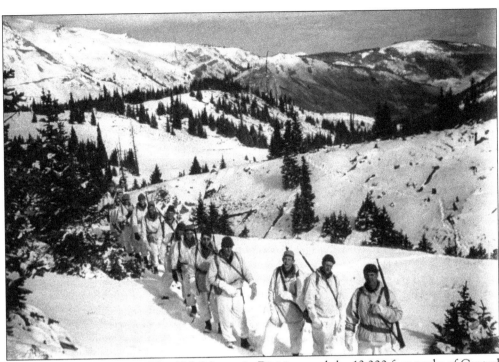

**Training on the Divide.** The 10th Mountain Division used the 13,000-foot peaks of Central Colorado as a training ground. In 1944, the unit was deployed to the Apennine Mountains of northern Italy, where they suffered heavy casualties while taking Mount Belvedere from the German army. (Courtesy of National Ski Patrol.)

**NSP Members.** National Ski Patrol members gather around a patient while they practice applying a splint. The NSP was founded in Stowe, Vermont, in 1938 and moved its headquarters to Denver 10 years later, where it is located today. (Courtesy of National Ski Patrol.)

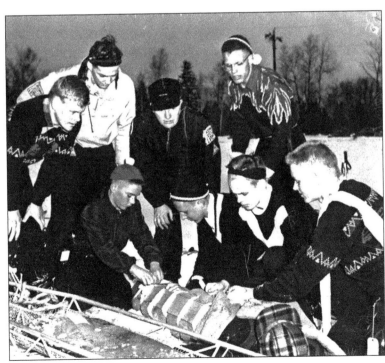

**LIFT TICKET.** Monarch Mountain opened in 1936 with a rope tow powered by a pickup truck engine. Tow tickets during the first season cost just 25¢, and skiers were reminded to ski safely. Ski patrol and mountain rescue techniques at ski areas across Colorado were still in their infancy. (Courtesy of Monarch Mountain.)

**THE EARLY YEARS.** Skiers enjoy a day on Monarch Mountain. By 1939, the area offered a small lodge, hand-cut trails, and a lift. While on-mountain amenities were few, options for rescue were even more so. In extreme circumstances, assistance from the US Forest Service may have been available. (Courtesy of Monarch Mountain.)

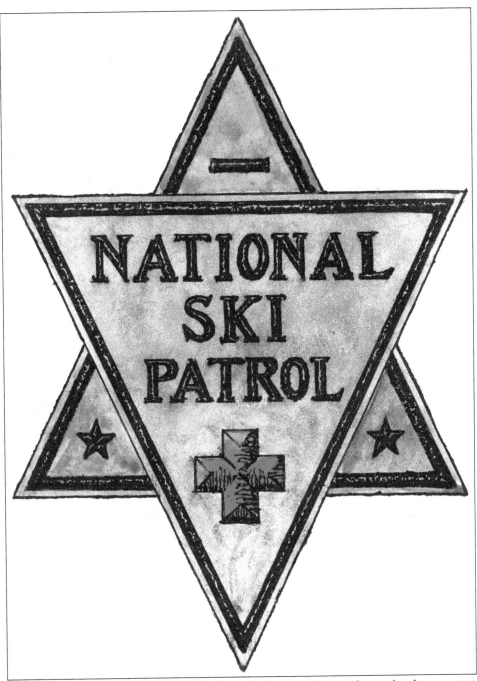

**NSP.** The National Ski Patrol is the largest federally chartered nonprofit membership association that serves public safety for mountain recreation in the United States and in some military areas in Europe. The association was established in 1938 by Charles "Minnie" Dole. The headquarters moved to Denver from New England in 1949, and NSP was incorporated in 1953 when Dole stepped down as director. His successor, Edward Taylor, took over on the condition that the organization be headquartered in Denver. This early logo was worn by members to identify them on the slopes. (Courtesy of National Ski Patrol.)

**TOBOGGAN RESCUE.** Two National Ski Patrol members practice loading and transporting a patient in a toboggan. While technology and medical protocols have changed, the toboggan remains one of the most important tools used by ski patrollers. (Courtesy of National Ski Patrol.)

**PATROL SHACK.** Wolf Creek Ski Area began operation in 1938 with the construction of Wolf Creek Pass. It was not until the mid-1950s that the area saw significant investment in new amenities and upgrades, including a new ski patrol outpost. (Courtesy of Wolf Creek Ski Area.)

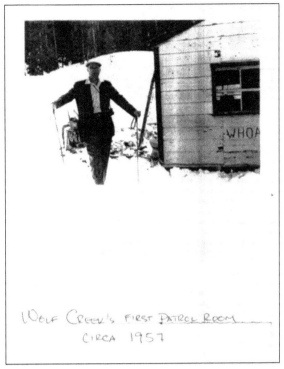

Wolf Creek's First Patrol Room Circa 1957

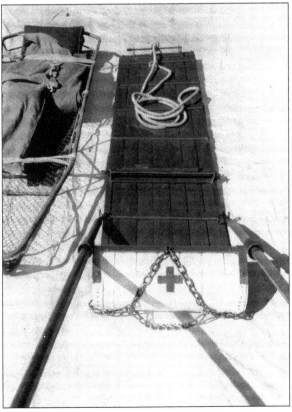

**TOOLS OF THE TRADE.** The Sun Valley rescue toboggan was a breakthrough piece of equipment when it was first used in 1946. The hickory toboggans securely held a removable Stokes litter and had a chain at the front that could be lowered into the snow to provide more control and braking power. The toboggans were designed by Nelson Bennett, a patroller at Sun Valley, Idaho, and member of the 10th Mountain Division who lived until 2016. He was 101. (Courtesy of National Ski Patrol.)

**IMPROVISED TOBOGGAN.** If a Sun Valley toboggan was not available, ski patrollers practiced improvising them, like in this photograph. Tools specific to mountain rescue were born out of years of trial and error. (Courtesy of National Ski Patrol.)

**EARLY TOBOGGANS.** Patrollers at Aspen Mountain transport an injured skier using techniques of the day. The photograph was taken in 1950, just three years after Aspen Mountain began operation. Many of the mountain's first patrollers (including Pete Seibert, who went on to establish Vail Ski Resort) were veterans of the Army's 10th Mountain Division. (Courtesy of Aspen Historical Society.)

**HOTDOG.** A skier shows off his skills while flying through the air at Monarch Mountain in the early 1950s. The area is one of the oldest continuously operating mountains in Colorado. (Courtesy of Monarch Mountain.)

**STEAMBOAT PATROL.** Steamboat Springs is home to a long history of skiing, including the country's longest continuously operated ski area. Howelsen Hill near downtown Steamboat Springs first opened in 1914. Skiing opportunities in the Yampa River Valley grew substantially when Steamboat Ski Resort opened nearby on January 12, 1963. The following year, Steamboat Ski Resort patrollers posed for this team photograph. Early patrol members included Carl Henderson, Ken Kilborn, Dennis Lodwick, Bob McNeil, Esther (DeliQuadri) McPherson, Merle Nash, and Ralph Selch. (Courtesy of Tread of Pioneers Museum.)

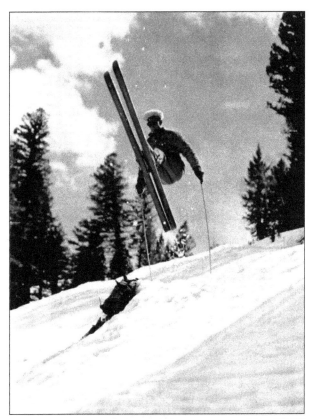

For sale by the Superintendent of Documents, U. S. Government Printing Office, Washington 25, D. C.
Price 60 cents

**Avalanche Control.** Early avalanche mitigation in Colorado was directed by the US Forest Service snow ranger program. This handbook issued by the US Department of Agriculture around 1950 was used as guidance and has seen many updates. By 1951, the first reported avalanche rescue at a ski area by ski patrollers was performed at Arapahoe Basin on November 17. George Bakalyar, a 29-year-old skier from Denver, was witnessed triggering an avalanche and located in a debris pile with his hand sticking out of the snow. Ski patrols across the state now take a leading role in avalanche mitigation within ski area boundaries. (Courtesy of National Ski Patrol.)

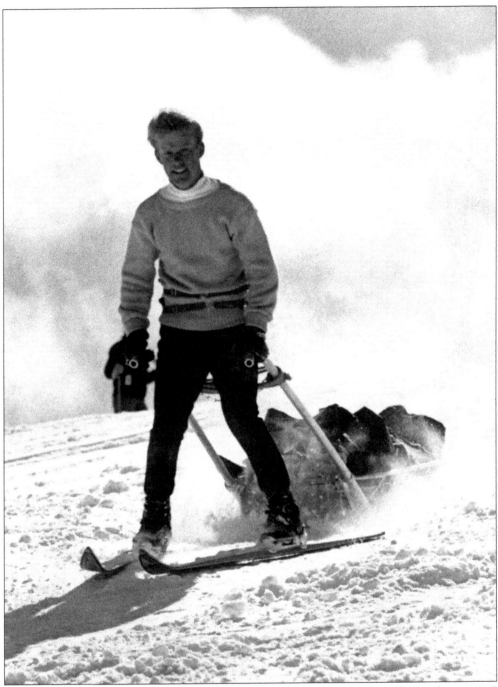

**WILD WEST.** Michael Ohnmacht was born in Austria in 1940 and was inspired by "cowboy movies" and the open space of the American West. He moved in 1960 to Aspen, where he began work a ski patroller at Buttermilk Ski Area that same year, also the year this photograph was taken. (Courtesy of Aspen Historical Society.)

**JIM BLANNING.** Two patrollers at Aspen Mountain splint a skier's leg in 1960. The man on the right, Jim Blanning, watched his hometown of Aspen transform from an old mining town to a vacation spot for the rich and famous. After feuding with city officials over his own mining sites around town and serving a prison sentence for fraud, he retaliated by planting four bombs around Aspen on New Year's Eve 2009. The 72-year-old Blanning was found dead of a self-inflicted gunshot near his Jeep. A note left behind read in part, "I was and am a good man." (Courtesy of Aspen Historical Society.)

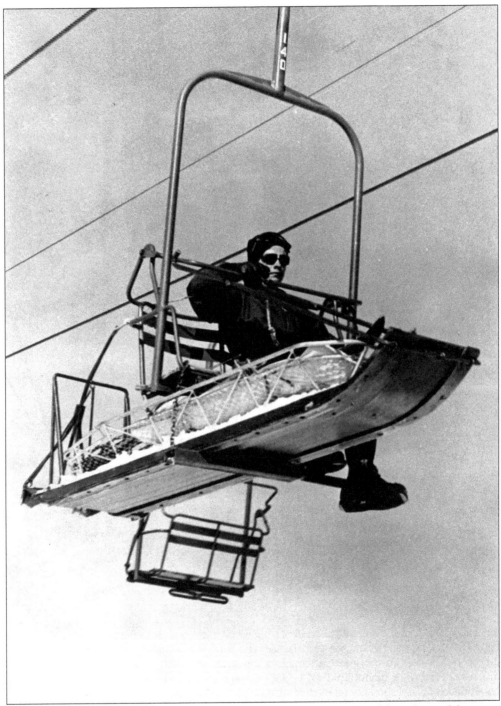

TOBOGGAN LOADING. A patroller loads an empty toboggan on a chairlift at Aspen Mountain in 1960. Chairlifts are used to move patrollers and their equipment to the top of the mountain, where they are in a position to respond in case of an emergency. Various techniques for hauling toboggans up chairlifts include the very simple method of patrollers holding them on their laps. (Courtesy of Aspen Historical Society.)

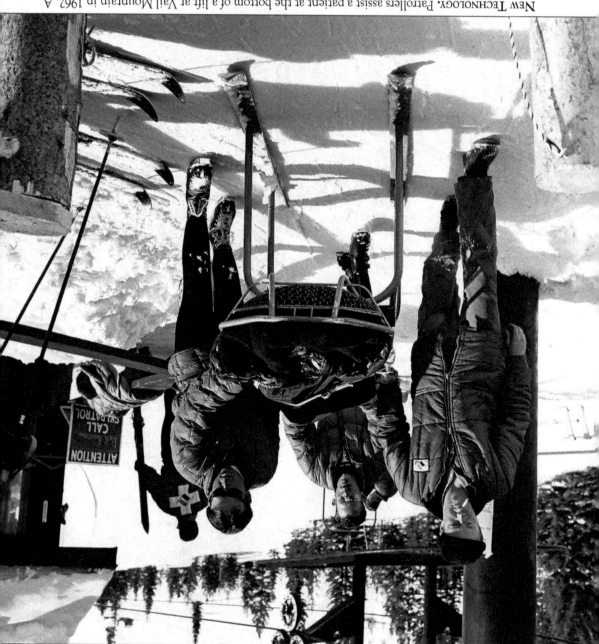

**NEW TECHNOLOGY.** Patrollers assist a patient at the bottom of a lift at Vail Mountain in 1962. A litter could be used to transport patients in a toboggan and then transferred to an improvised sled at the base of the mountain. By the 1960s, advances in technology brought taller and stiffer boots made of plastic and fiberglass that added support and reduced ankle injuries. (Courtesy of Vail Resorts.)

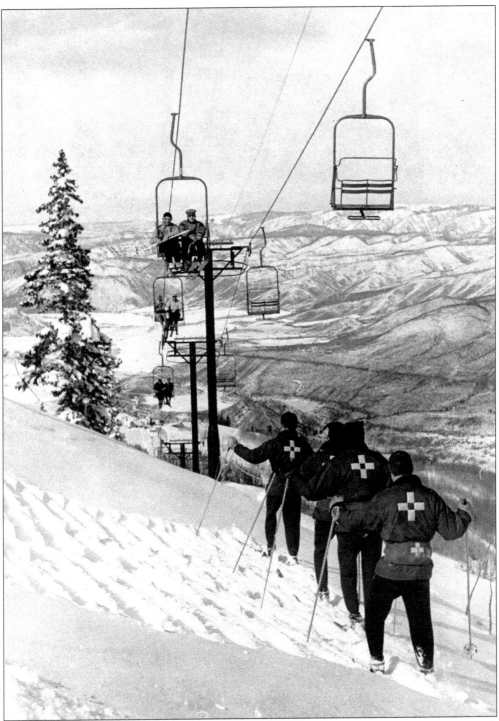

**BOOTPACKING.** Members of Aspen Ski Patrol methodically use their skis to compact the snow beneath a chairlift around 1960. The technique, known as "bootpacking," compresses snow and disrupts layers within the snowpack. Patrollers use the technique to preserve snow on the slopes and reduce avalanche hazard on steeper terrain after snowstorms. (Courtesy of Aspen Historical Society.)

**SKI PATROL STRIKE.** After voting to form the Teamsters Union Local No. 961 Professional Ski Patrolmen and Trail Crew, Aspen ski patrollers staged a strike against Aspen Skiing Corporation during the winter of 1971 in protest of unfair wages. The journalist Hunter S. Thompson, who lived in Aspen, wrote at the time of the "savage strike" in a letter to a *New York Times* editor that was later published in *Fear and Loathing in America*. Aspen, as he observed, was "committing financial suicide" and the patrolmen's strike was shaping up to be a "king-hell sport story." (Courtesy of Aspen Historical Society.)

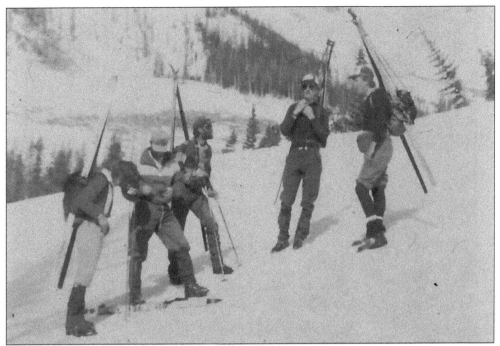

**MOUNT PECK TOUR.** Patrollers from Monarch Mountain explore the nearby backcountry on a day off from ski patrol. From left to right are Jacki Faith, unidentified, Dave Sheefer, Ron Bunk, and Ned Stock. (Courtesy of Deborah Davies.)

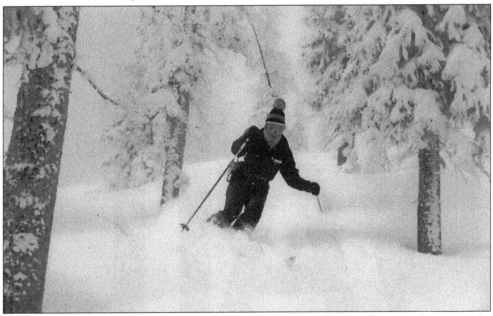

**DEBORAH DAVIES.** Deborah Davies joined Monarch Mountain Pro Patrol in 1974, becoming the area's first female patroller. After several years at Monarch, she moved on to become a patroller at Conquistador Ski Resort and opened a small ski shop in nearby Westcliffe. When the resort closed in 1988, so did her shop. "It was such an awesome time of my life," she said while reflecting on her years as a ski patroller in Colorado. (Courtesy of Deborah Davies.)

**VAIL GONDOLA.** This vintage poster from 1962 depicts the original Vail gondola. The four-person lift served the base area from 1962 to 1967. The ski area was founded by former Aspen patroller Pete Seibert. (Courtesy of Vail Resorts.)

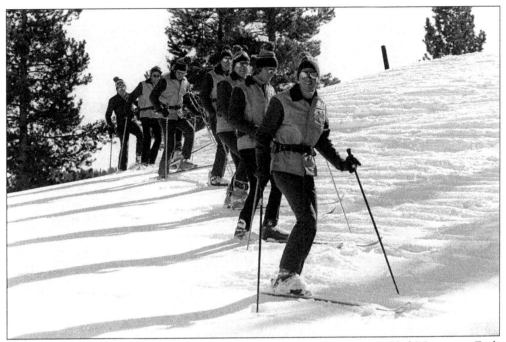

**ROOKIE PATROL.** Patrol recruits line up during the 1974–1975 season at Vail Mountain. Each season, new patrollers are introduced to the rigors of ski patrolling. From memorizing detailed map locations to honing medical skills, it is often joked that a patroller's "rookie year" can last for several seasons. (Courtesy of Vail Resorts.)

**MIRKWOOD BASIN.** Three patrollers wait for explosive charges to detonate at the top of Mirkwood Basin on the Continental Divide at Monarch Mountain. The charges are ignited and thrown by hand into Mirkwood Bowl to initiate avalanches ahead of the skiing public. The bowl and nearby trail names like Orcs and Gollum's were inspired by the fantasy book series *The Lord of the Rings*. (Courtesy of Deborah Davies.)

**VAIL PATROL.** From left to right, patrollers Zorro, Peter, and Frank show off their skis at Vail Mountain around 1963–1964. (Courtesy of Vail Resorts.)

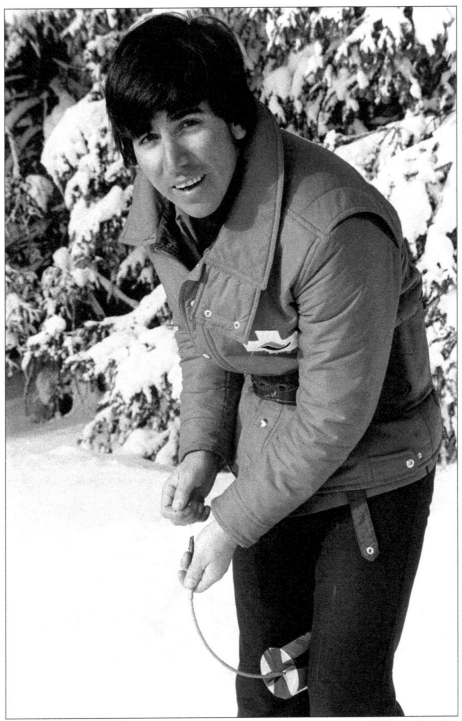

HAND CHARGES. A patroller prepares to pull a friction igniter on a hand-delivered avalanche charge. The photograph was taken on a mitigation route during the 1975–1976 season at Vail Mountain. It remains an industry standard to ignite hand charges for avalanche mitigation with pull-wire friction igniters. (Courtesy of Vail Resorts.)

of Vail Mountain

BACK BOWLS — SUMMIT ELEVATION 11,250'-3429 METERS

TO SUN UP BOWL — HEADWALL RIDGE

BASE ELEVATION 8200'-2499 METERS

Bowls

SUMMIT ELEVATION 11,250'-3429 METERS

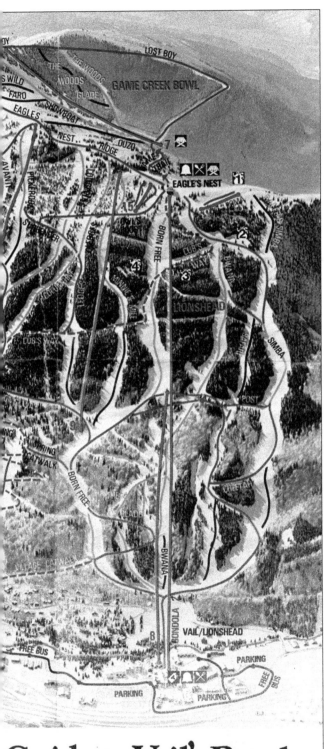

# Guide to Vail's Bowls

**Before China Bowl.** This 1975 map of Vail Mountain shows an earlier version of the ski area. By 1988, Vail had expanded its boundary to include China Bowl and constructed Two Elk Lodge at the top, making the resort the largest in North America. (Courtesy of Vail Resorts.)

**LIONSHEAD GONDOLA.** Nancy and Rob pose for a photograph under the Lionshead gondola at Vail Mountain. On March 26, 1976, two gondola cars plunged 124 feet to the ground, killing four passengers. It was the deadliest ski accident in Colorado at the time. An onlooker from the ground said the gondola cars looked like "apples falling from a tree." (Courtesy of Vail Resorts.)

**AFTER THE CRASH.** The Lionshead Gondola returned to service in 1977. At the time of the incident, Vail employed 29 full-time patrollers. The ski area was among the first in the United States to employ a full professional patrol, where the highest-paid members made around $1,200 per month.

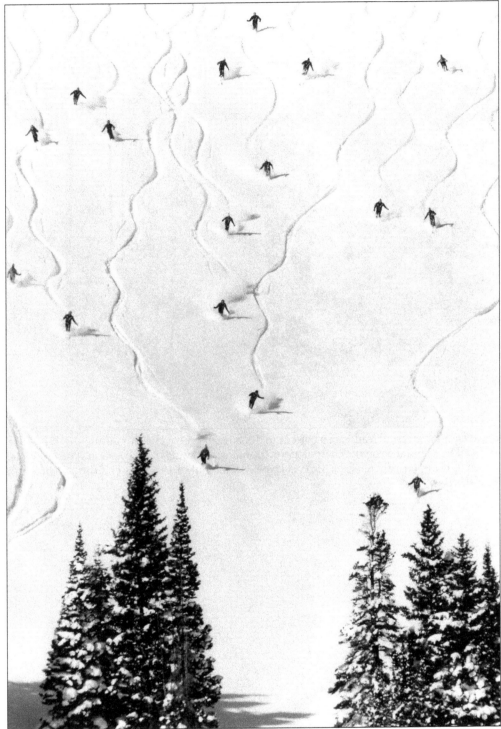

**LET 'EM HAVE IT.** Skiers make turns through freshly fallen snow after the slope was opened by Vail Mountain ski patrol. Ski patrollers are charged with ensuring avalanche hazards have been properly mitigated before an area is opened to the public. (Courtesy of Vail Resorts.)

CHAIRLIFT. Patrollers at Vail load a patient in a toboggan onto a chairlift during the 1977–1978 season. The jig installed on the chair supports the toboggan during the extrication. The technique is used to transport patients from areas of the mountain only accessed by chairlift. (Courtesy of Vail Resorts.)

# *Two*

# FIRST RESPONDERS

Injuries are an unfortunate reality on a ski mountain. In order to respond to medical emergencies, patrollers are trained in pre-hospital medicine and act as first responders. The primary role of a patroller in response to a medical emergency is to provide basic life support and transportation to more advanced care.

As a requirement, patrollers in Colorado hold a combination of emergency certifications including Wilderness First Responder, Outdoor Emergency Care (OEC), and Emergency Medical Technician (EMT), or certifications in advanced medical care like paramedic or higher.

In the United States, a standard for pre-hospital emergency care emerged in the mid-1970s in response to increasing highway traffic accidents. The EMT certification was created when the National Highway Traffic Safety Administration established a set of training requirements for first responders.

Ski patrol organizations began adopting the new medical standards for use on the mountain. By 1976, Vail Mountain had become one of the country's first ski areas to require all 29 of its full-time patrollers to have taken the 82-hour advanced first aid training.

Shortly after the introduction of the EMT certification, the National Ski Patrol developed the OEC certification in the late 1980s to cater specifically to the situations patrollers encountered. The OEC certification is similar to EMT but focuses on the use of equipment like toboggans available to patrollers in an alpine environment.

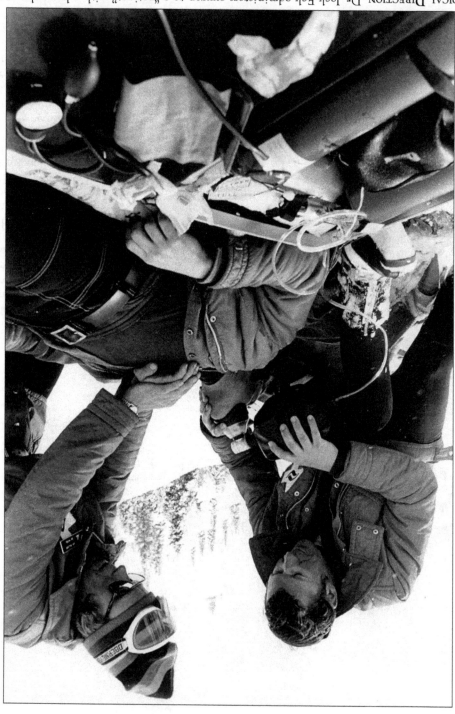

MEDICAL DIRECTION. Dr. Jack Eck administers oxygen to a "patient" with a bag valve mask. After a tour as a flight surgeon in Vietnam, Dr. Eck landed a job in the new on-hill clinic at Vail Mountain in 1971. There, he continued a long 41-year career as the first medical advisor for Vail patrol and was often seen on the mountain wearing the recognizable red jacket and white cross. (Courtesy of Colorado Snowsports Museum and Hall of Fame.)

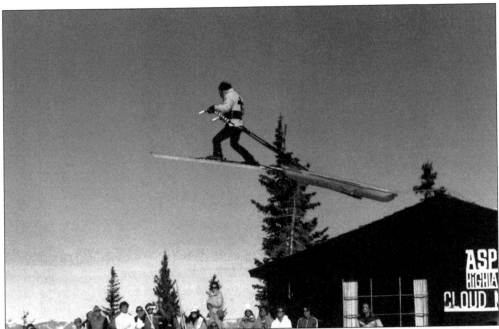

**CLOUD NINE.** Mack Smith flies over the deck of the Cloud Nine Bistro at Aspen Highlands with a toboggan in 1975. Smith has been the patrol director at Highlands for over 40 years but has long since stopped participating in the once frequent spectacle of jumping the deck with a toboggan. (Courtesy of Aspen Historical Society.)

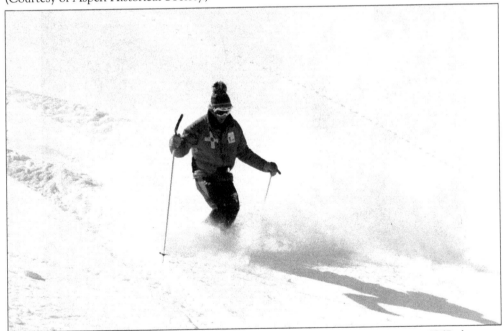

**SKI PIONEER.** Hal Hartman skis through the Hanging Valley area of Snowmass in 1967, the same year the ski area opened. Hartman worked as patrol director at Aspen Mountain for several years before playing an instrumental role exploring and promoting what would become Aspen Snowmass, where he also patrolled until the mid-1970s. (Courtesy of Aspen Historical Society.)

ORIGINAL GONDOLA. One of the first lifts available for skiers when Vail Mountain opened in 1962 was the original Vail gondola. The ski area was founded by Pete Seibert, a member of the US Army's 10th Mountain Division and former Aspen Mountain Ski Resort ski patroller. The gondola helped transform the uninhabited valley into one of the largest ski areas in North America. (Courtesy of Vail Resorts.)

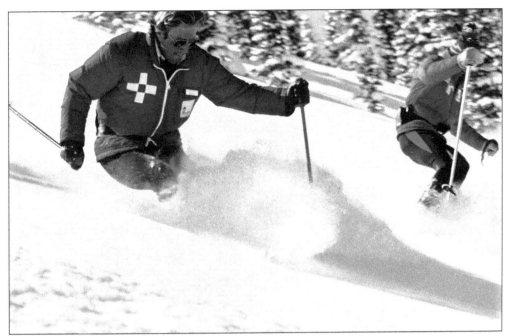

**RECON.** Patrollers ski through the Hanging Valley area on Snowmass Mountain on a reconnaissance lap in 1976. Aspen Snowmass began operation in December of that year.

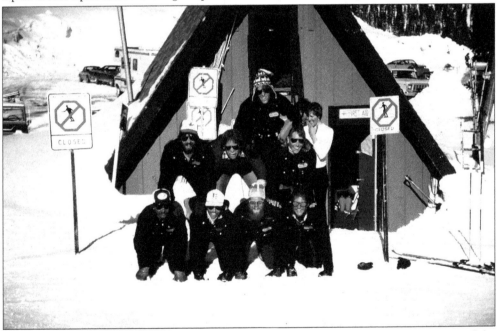

**A-FRAME.** Until 1986, Monarch Ski Patrol operated from this A-frame near the bottom of the ski area. In the top of the building were the offices for Great Divide Snowcat Tours, which eventually became Monarch Snowcat Tours. From left to right are (first row) patrol director Scott Stevenson, assistant director Rich Moorehead, Dave Davies, and Pete Jorgensen; (second row) John Englebrecht, mountain manager Ned Sock, and Deborah (Krall) Davies; (third row) Paul Tuttle. (Courtesy of Deborah Davies.)

SNOW PIG. A Vail Mountain snowcat is decorated as an abominable snow pig gobbling unsuspecting skiers during the 1982–1983 season. Patrollers have, at times, needed to confront unhappy guests. In jest, patrollers at Vail found a different way. (Courtesy of Vail Resorts.)

AVALANCHE MITIGATION. A patroller prepares to lob an avalanche charge during mitigation efforts at Vail Mountain during the 1983–1984 season. Triggering instabilities within the snowpack with explosives allows the snow to settle and minimize avalanche hazard before skiers enter the slope. (Courtesy of Vail Resorts.)

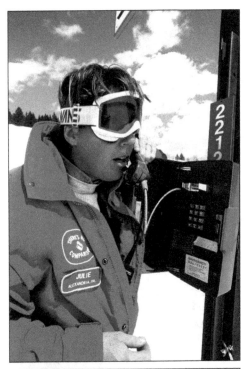

**EMERGENCY PHONES.** Patroller Julie Rust calls patrol headquarters on an emergency phone at Vail Mountain. Emergency phones and radios like the one seen inside her jacket are used to dispatch patrollers to tasks around the mountain. (Courtesy of Vail Resorts.)

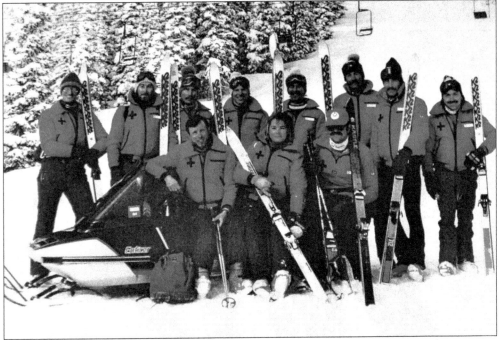

**SKI PATROL, 1983.** While terrain on Monarch has not changed much over the years, advancements in ski technology have changed equipment dramatically. Monarch ski patrollers during the 1983–1984 season show off the skis of the day near the bottom of the Breezeway lift. Rich Moorhead, third from left, said they included skis in the photograph because they were trying to get a ski sponsorship. (Courtesy of Monarch Mountain.)

**JOHN CALLAHAN.** A 20-year patroller for the Aspen Skiing Co., Callahan also volunteered for Mountain Rescue Aspen for 25 years, where he was a founding member and participated in hundreds of rescues. He is known best for his adventurous spirit and fluent Spanish. In 2017, Callahan was inducted into the Aspen Hall of Fame. This photograph of him in uniform was taken at Buttermilk Ski Area in 1983. (Courtesy of Aspen Historical Society.)

**ASPEN PATROL.** Members of Aspen Ski Patrol stand atop a ridge in 1982. While uniforms have changed, the recognizable white cross has long been used to distinguish ski patrollers on the mountain. Working that day were, from left to right, Eric Kinsman, Tony Popish, Ed Cross, Jim Cerise, and Alex Halperin, who began patrolling in 1978 as the area's first female patroller. (Courtesy of Aspen Historical Society.)

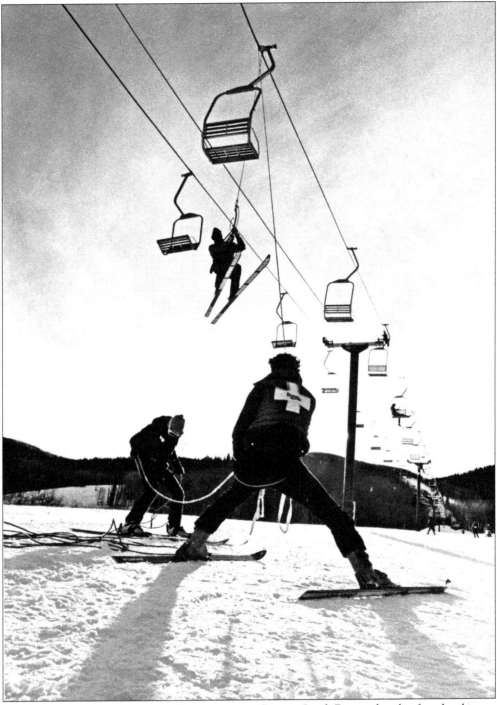

**LIFT EVAC.** Patrollers practice a lift evacuation at Beaver Creek Resort shortly after the ski area was established in 1980. The technique is used to lower guests in the event of a lift malfunction. The ability to climb lift towers and execute a high-angle rope rescue is an important part of a patroller's responsibility. The state of Colorado also enforces evacuation standards across all ski areas. (Courtesy of Vail Resorts photograph archive.)

AVALAUNCHER. While handling the round carefully, Campian examines the next projectile to be fired during the 1984–1985 season at Arapahoe Basin. From a tower in the "shooting gallery," the explosives are propelled by compressed air and designed to discharge on impact in hard to reach areas of the mountain. (Courtesy of Arapahoe Basin Ski Patrol.)

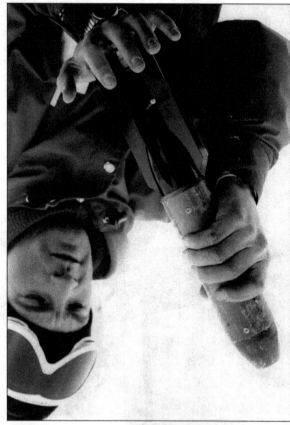

EAST WALL. Mark "Campo" Campian prepares an avalanche round during the winter of 1984–1985. Arapahoe Basin uses the "avalauncher" as part of mitigation efforts in an area known as the East Wall. (Courtesy of Arapahoe Basin Ski Patrol.)

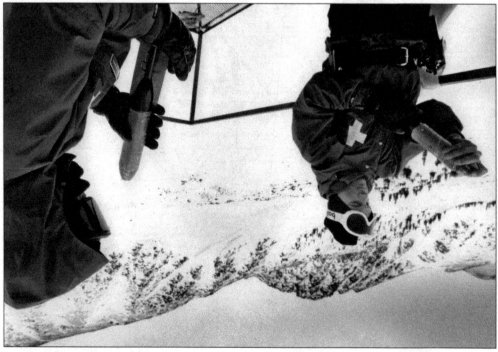

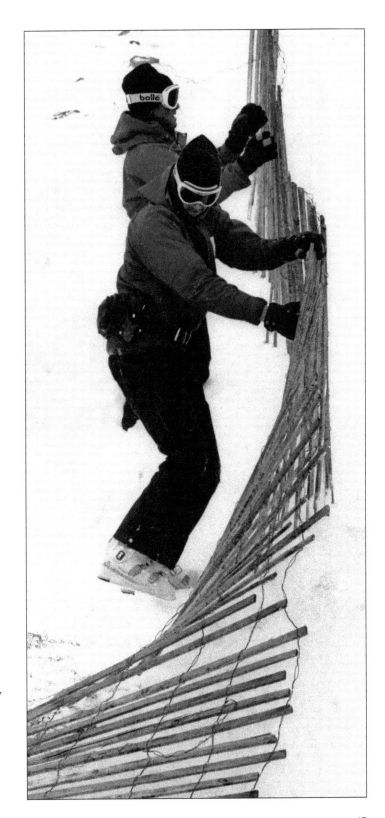

SNOW FENCE. Patrollers install a snow fence during the 1984–1985 season at Arapahoe Basin. The temporary fencing is used to retain snow by promoting snow drifts and obstructing wind and blowing snow. This low-tech method of snowmaking is still in use at many ski areas. (Courtesy of Arapahoe Basin Ski Patrol.)

**WINTER CATALOG.** The National Ski Patrol's winter catalog depicted a snowy scene on the cover of the 1985 issue. (Courtesy of National Ski Patrol.)

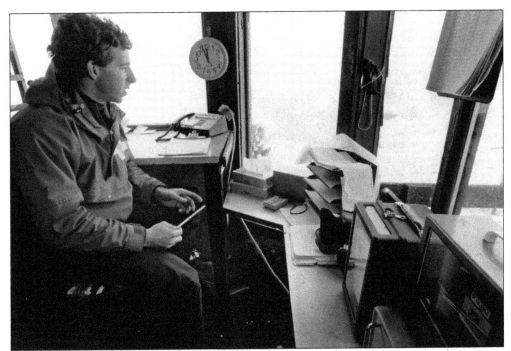

**WEATHER READING.** Tim Finnigan dispatches from the Snow Plume Refuge during the 1984–1985 season. Instruments on the desk were used to make weather observations. Patrollers could then be sent to areas to mitigate potential avalanche hazards within the ski area boundary. (Courtesy of Arapahoe Basin Ski Patrol.)

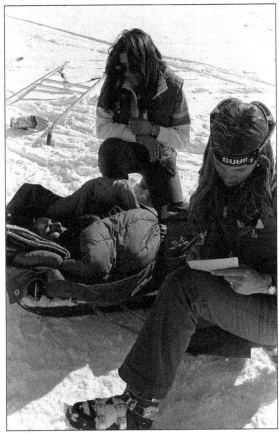

**OUTDOOR EMERGENCY CARE.** In 1980, these patrollers are documenting medical treatment performed on the hill. That same year, an OEC certification was introduced as the standard for emergency care in a non-urban setting intended for use by ski patrollers in Colorado. Today, many ski patrollers hold an OEC certification in addition to others, like EMT or paramedic certification. Documentation is an important part of patient care in the link between the ski hill and the hospital. (Courtesy of Vail Resorts.)

**THE DAILY GRIND.** The daily patrol responsibilities include many small details. Crash pads on lift towers and fence posts need to be raised and lowered to sit flush with the changing snow level. The chore can be tedious. While these two patrollers adjust a pad, two of their partners laugh from the chairlift. (Courtesy of Vail Resorts.)

BEHIND THE SCENES. Patrolling for some is a year-round job. During the summer of 1978, an anemometer was replaced at one of Vail Mountain's weather stations. Once winter returns, patrollers pay close attention to the weather, coming in before sunrise to interpret the latest information gathered from the mountain. The anemometer is used to record wind speed, which provides critical information for assessing avalanche potential. (Courtesy of Vail Resorts.)

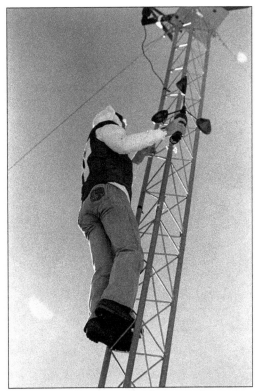

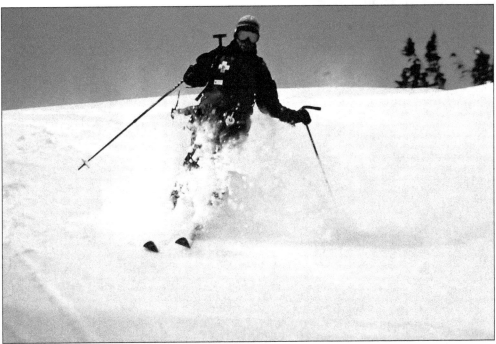

FRESH SNOW. Karen Davis finds fresh snow at Breckenridge Ski Resort in 1995. Work for a ski patroller often requires long days in challenging alpine environments. On other days, fresh powder turns on clear days break up the work routine. (Courtesy of Matt Krane.)

BEAVER CREEK. This aerial photograph shows Beaver Creek, which opened on December 15, 1980, during a boom time for alpine skiing. In 1993, neighboring Arrowhead Mountain was purchased

by Vail Resorts, and four years later, Beaver Creek was expanded to include the former Arrowhead Mountain within the newly defined resort boundary. (Courtesy of Vail Resorts.)

TIM COONEY. When photographed in 1983, Tim Cooney had already been a patroller at Aspen Mountain for five years. It was just the beginning of what would become a long and storied career in the Roaring Fork Valley. He continues to work as a writer and historian, often with ski patrol as his subject. (Courtesy of Aspen Historical Society.)

PETER WERNER "PETE" SEIBERT. Pete Seibert was a member of Aspen Mountain Ski Patrol and the founder of Vail Mountain, where he was photographed skiing sometime after the resort opened in 1962. During World War II, Seibert served in the famed 10th Mountain Division and was inducted into the Colorado Ski and Snowboard Hall of Fame in 1980 for his contributions to the sport of skiing and snowboarding in Colorado. (Courtesy of Vail Resorts.)

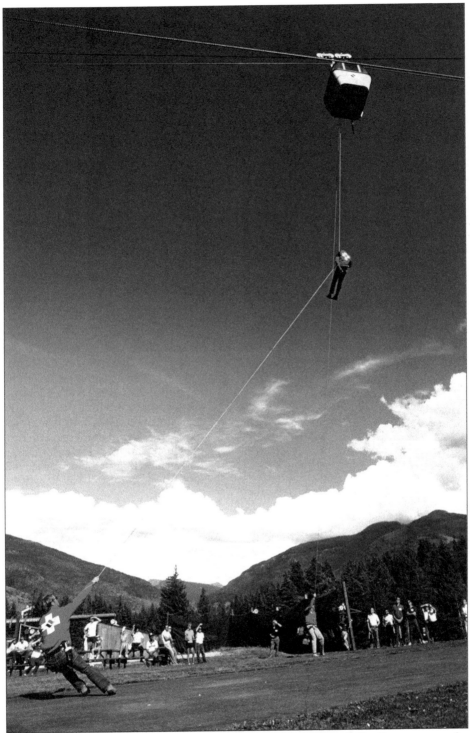

**PRACTICE MAKES PERFECT.** Training keeps rescuers on top of their skills. On a summer day in 1983, onlookers watch as patrollers practice a gondola evacuation using rope rescue techniques. (Courtesy of Vail Resorts.)

**SUNNY DAYS.** Ski patrollers and other Vail Mountain employees show off the latest in 1990s fashion and equipment. For the first time during the 1990 season, Vail Mountain, along with Beaver Creek Ski Resort, hosted the World Alpine Ski Championships. The event rocketed Vail Mountain into the worldwide media spotlight. (Courtesy of Vail Resorts.)

**HAND CHARGE.** Patroller Paul Bayne prepares to throw an avalanche mitigation charge on Tucker Mountain at Copper Mountain during the 1986–1987 winter season. (Courtesy of Matt Krane.)

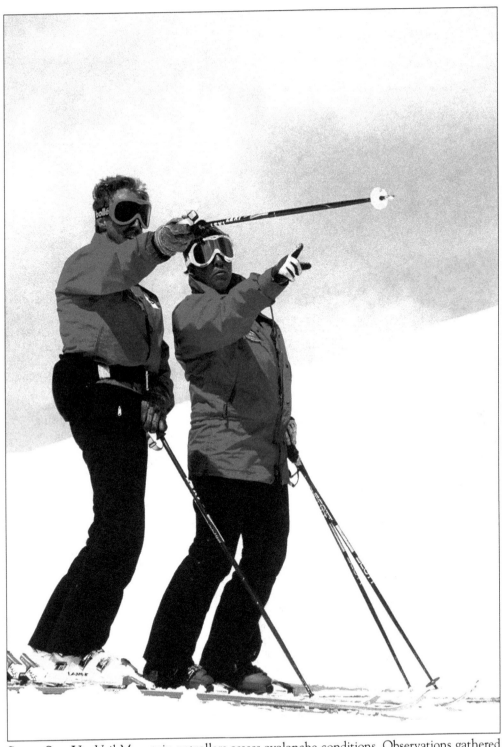

**SCENE SIZE-UP.** Vail Mountain patrollers assess avalanche conditions. Observations gathered from nearby slopes can inform decisions made during travel in hazardous terrain. (Courtesy of Vail Resorts.)

**CONTROL MORNING.** Patrollers traverse to the Back 9 at Breckenridge to perform avalanche mitigation in the Twin Chutes area during the 1995–1996 season. Traveling in teams and crossing particularly hazardous areas one at a time helps minimize risk in avalanche terrain. When working to reduce avalanche hazard, the term "avalanche mitigation" is preferred by patrollers over the use of "avalanche control," because even with advanced techniques, the forces of nature in the mountains can never be controlled. (Courtesy of Matt Krane.)

**OLD LIFT 4.** Patrollers ride Lift 4 on Peak 8 at Breckenridge Ski Resort during the winter of 1986–1987. The aging lift was replaced by the four-person Peak 8 SuperConnect in 2002. (Courtesy of Matt Krane.)

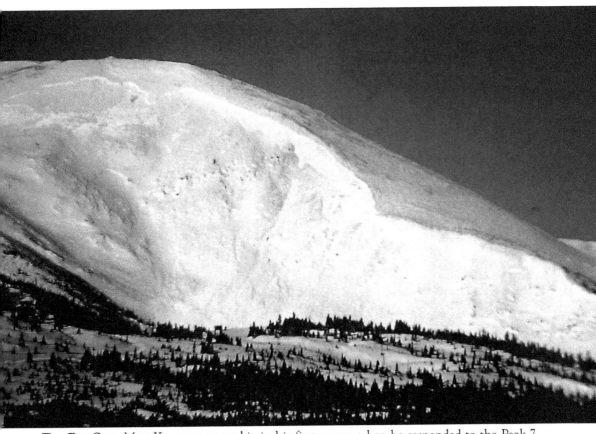

**THE BIG ONE.** Matt Krane was a rookie in his first season when he responded to the Peak 7 avalanche near Breckenridge Ski Resort in 1987. The massive slide occurred in an area that was, at the time, outside of the Breckenridge Ski Resort boundary. "It was a nightmare waiting to happen," said patroller Mary Logan after the incident. The half-mile-wide avalanche was triggered by skiers who had left the resort boundary. Over 200 volunteers and patrollers responded to search the 20-foot-deep debris pile that covered over 23 acres. Skiers Martin Donellan, Paul Way, Nicholas Casey, and Alexander Cates were killed in the avalanche. The incident drew scrutiny to backcountry access points at ski areas throughout Summit County, where the incident had occurred. (Courtesy of Matt Krane.)

**AVALANCE PROBE LINE.** Rescuers form a probe line to search for skiers buried by the massive avalanche that occurred just outside the Breckenridge ski area boundary on Peak 7 in 1987. Probes are rescue tools that are painstakingly inserted into the snow to locate skiers within the debris. After four days, with help from rescuers from around the country, and 6,200 man-hours, the fourth skier buried by the avalanche was located. (Courtesy of Colorado Snowsports Museum and Hall of Fame.)

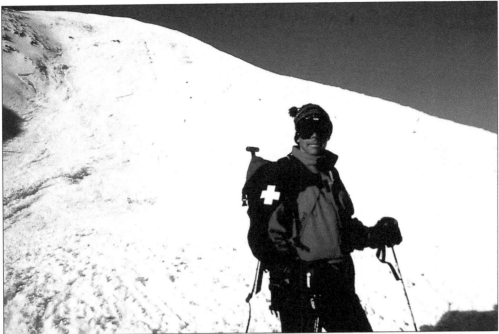

**PEAK 7.** Rick Sandstrom stands in the debris pile of an avalanche on Peak 7 during the 1995–1996 season. The slope is the same area where a much large avalanche, "the Big One," occurred around nine years earlier. In 2002, Breckenridge expanded to include Peak 7 within the resort boundary. Ski patrol now regularly conducts avalanche mitigation work there. Courtesy of Matt Krane.)

**MONARCH SNOWMOBILE.** Michael Ambrose poses with a snowmobile at Monarch Mountain. Known for his sense of humor, Ambrose now works part-time as a patroller and wilderness first responder instructor in Vermont. (Courtesy of Monarch Ski Patrol.)

**MIRKWOOD MITIGATION.** Explosive charges ring out along the Continental Divide during avalanche mitigation work in Monarch Mountain's Mirkwood Basin. (Courtesy of Deborah Davies.)

**VAIL PATROL.** Patrollers enjoy a spring day at Vail Mountain in a photograph taken around 1988. (Courtesy of Vail Resorts.)

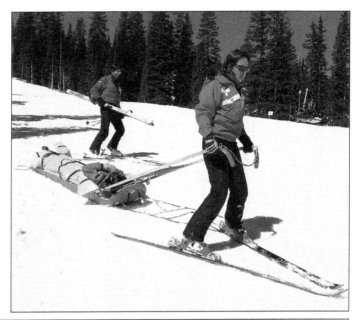

**TOBOGGAN RIDES.** Leslie Felts "drives" a patient down Little Mo in a toboggan at Monarch Mountain in 1991. Toboggans are commonly used by ski patrollers for extricating patients injured on the hill. (Courtesy of Frank Staub.)

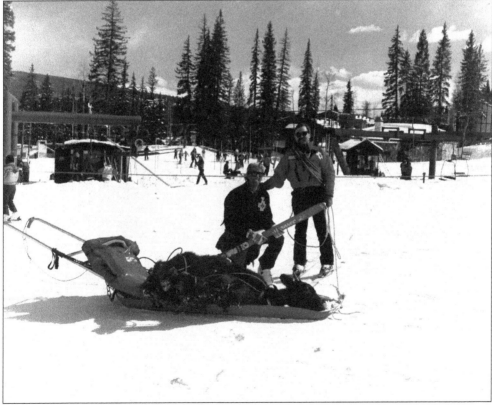

**RUSSIAN COWBOY.** Ivan Unkovskoy kneels beside former patrol director "Dirty" Don Hinkley and one of three head of cattle trapped on the back side of Purgatory Resort in 1994. After trying for much of the winter to get the cattle out, Dirty finally roped them, and Unkovskoy the "Russian Cowboy" lashed them to a toboggan and hauled them out. (Courtesy of Josh Baker.)

CAT SKIING. In 1990, Great Divide Snow Tours began driving guests and guides along the Continental Divide near Monarch Pass in search of deeper, untracked snow. The demand from guests for access to more extreme terrain has changed the way many ski areas regard their resort boundaries and how nearby areas are patrolled. (Courtesy of Monarch Mountain.)

DOING IT WRONG. Matt Krane began patrolling at Breckenridge Ski Resort in 1986. After a trip to Austria in 1996 to visit the Blizzard ski factory, he returned to Breckenridge with a new pair of skis. Mike Weinstein was there at just the right moment as Krane tried to show off the 222-centimeter-long skis. (Courtesy of Matt Krane.)

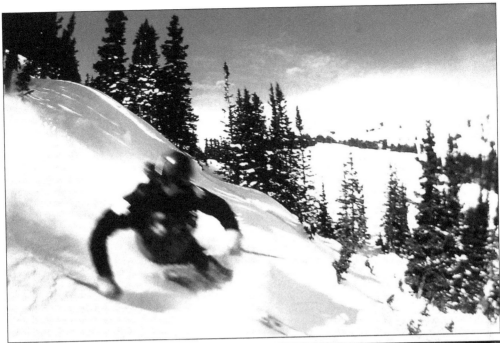

**POWDER SKIING.** Patroller Greg German skis through an area known as Snow White at Breckenridge Ski Resort in 1995. (Courtesy of Matt Krane.)

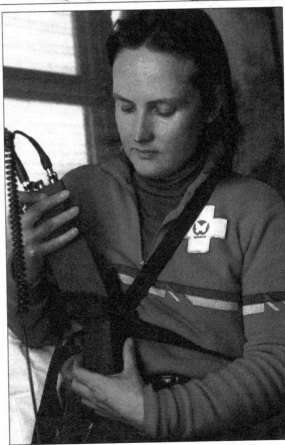

**RADIO CHECK.** Leslie Felts examines her radio before heading out for the day in 1991. This small step is an important part of maintaining equipment used on a daily basis. (Courtesy of Frank Staub.)

**TED KENNEDY JR.** You never know who you might meet while patrolling. Connecticut senator Ted Kennedy Jr. prepares for a run during an adaptive ski competition in Breckenridge in 1995. (Courtesy of Matt Krane.)

**BOARDER PATROL.** Snowboards are another tool that some patrollers choose to get the job done. As snowboards began to rise in popularity across Colorado, some skiers remained skeptical of the sport. Now, snowboarders are common on the slopes. (Courtesy of National Ski Patrol.)

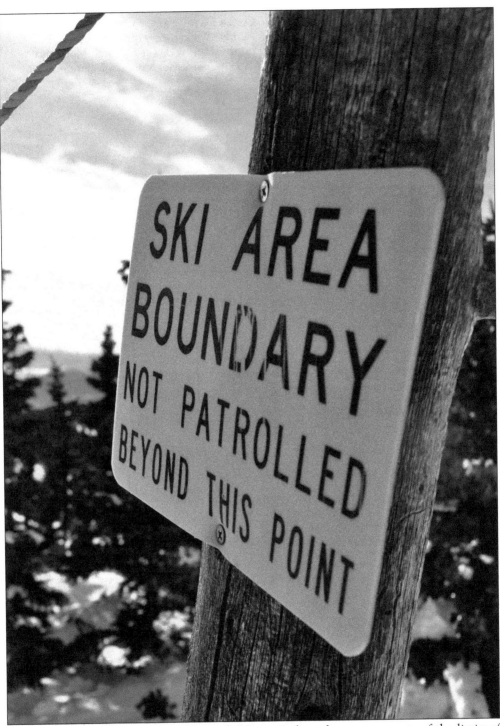

**AREA BOUNDARY.** This sign at a Monarch Mountain boundary warns guests of the limits of patrolled terrain. While areas outside the boundary can be accessed through designated points, skiers are expected to use safe backcountry travel techniques and prepare for their own self-rescue in the event of an emergency. (Courtesy of John Cameron.)

**GAPER DAY.** Patrollers Chad Hixon and Mark "Curly" Walker show off their best costumes during a spring day at Monarch Mountain in 1993. (Courtesy of Monarch Mountain.)

**BIRTHDAY TRADITION.** At Monarch Mountain, a long birthday tradition continues to this day. Each patroller, like Michael Ambrose, gets a birthday pie to the face. (Courtesy of Monarch Ski Patrol.)

THE WHEEL. During a ski patrol fundraiser at Monarch Mountain in 1995, patroller Josh Hadley guards "the Wheel of Misfortune." The wheel, which typically hangs in the patrol locker room, is used for a game of chance during the annual fundraiser. (Courtesy of Monarch Ski Patrol.)

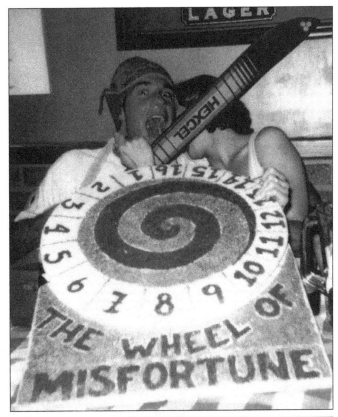

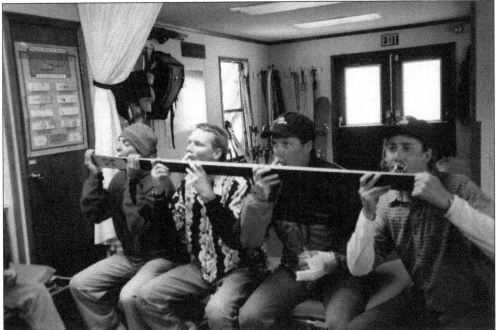

SHOT SKI. Patrollers share an after-sweep drink with a shot ski. Not surprisingly, this custom has become frowned upon in recent years. (Courtesy of Monarch Mountain.)

**BLACKHAWK DOWN.** On March 26, 2009, under heavy snowfall, Caswell Rico-Silver, then director of Monarch Ski Patrol, and others responded to a helicopter crash near the Monarch Mountain ski area boundary. Patrollers arrived to find the helicopter had been abandoned. A crew of three from the Alaska Army National Guard were traveling back to Alaska from Fort Carson in Colorado Springs when their Blackhawk helicopter crashed. Nick Sylvester, a patroller in his third season, heard the helicopter as it jettisoned its fuel tanks and flew low over the crowded ski area before falling silent behind the Continental Divide. The pilot, co-pilot, and crew chief walked away uninjured to nearby US Route 50 and hitchhiked into Salida. The US Army later retrieved the wreckage, but trees in the area still show damage from the crash. (Courtesy of Eric Miller.)

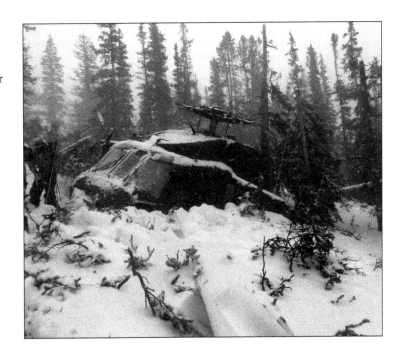

**WRECKAGE.** Eric Miller surveys the wreckage of the Blackhawk helicopter that crashed during a snowstorm in 2009. The crew of three managed to escape serious injury. (Courtesy of Eric Miller.)

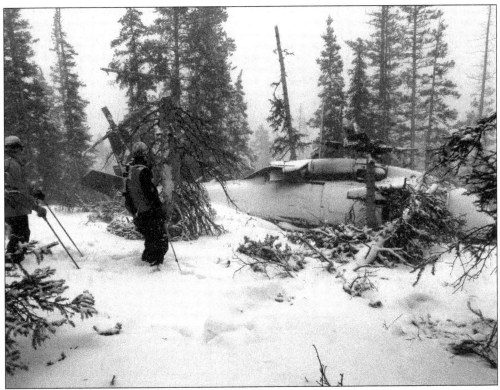

**NEAR MISS.** The sound was unmistakable as the helicopter roared overhead. The pilot jettisoned the fuel tanks over the busy ski area before it went silent, crashing to the ground just outside the ski area boundary. (Courtesy of Eric Miller.)

**SNOW PLUME REFUGE.** The Snow Plume Refuge was used as ski patrol headquarters at Arapahoe Basin until the building was replaced during the summer and fall of 2004. Before 1978, the original Snow Plume Refuge was used as a lift operator station for the Drummond lift, which preceded the Norway lift. (Courtesy of Arapahoe Basin Ski Patrol.)

**LEIF BORGESON.** A larger-than-life character beloved by many, Borgeson, the snow safety director at Arapahoe Basin, died of a heart attack while hiking the ridge at Aspen Highlands in February 2011. Borgeson was a career patroller who began at Keystone in the 1980s. He was 50 years old. (Courtesy of Arapahoe Basin Ski Patrol.)

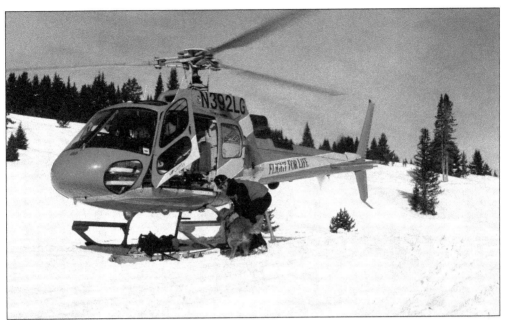

**C-RAD.** Leif Borgeson helps load dog Tane into a waiting helicopter at Arapahoe Basin in 2009. An avalanche rescue dog, handler, and avalanche technician are available to respond quickly to avalanches through the Colorado Rapid Avalanche Deployment program. (Courtesy of Arapahoe Basin Ski Patrol.)

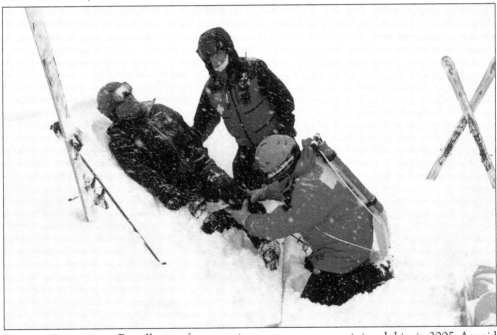

**PATIENT ASSESSMENT.** Patrollers perform a patient assessment on an injured skier in 2005. A rapid trauma assessment is used to efficiently identify the nature of the injury and any threats to life. Performing a good patient assessment is essential for providing good patient care. The methods for identifying injuries and illness are practiced frequently throughout the season by medical professionals. (Courtesy of National Ski Patrol.)

**TRAINING SCENARIO.** Members of the National Ski Patrol participate in a rescue scenario at Vail Mountain. Frequent training scenarios improve medical skills and begin at most areas before the chairlifts open for the ski season. Here, patrollers prepare to use a backboard, which immobilizes a patient's spine after an injury. (Courtesy of National Ski Patrol.)

**DEVIL'S TOOL.** Members of Arapahoe Basin Ski Patrol move a patient from a patrol toboggan to a waiting ambulance stretcher. The injured skier was swept by an avalanche outside the ski area boundary while skiing with a partner on April 1, 2011. "We saw the whole thing happen from the base clinic," said Tony Cammarata, director of Arapahoe Basin Ski Patrol. Devil's Tool is a backcountry ski line directly across the highway from the resort. Shortly after the incident, patrol received a letter from someone involved. "Thank you, thank you, thank you," it said, "he is an extremely lucky man to be alive today." (Courtesy of Arapahoe Basin Ski Patrol.)

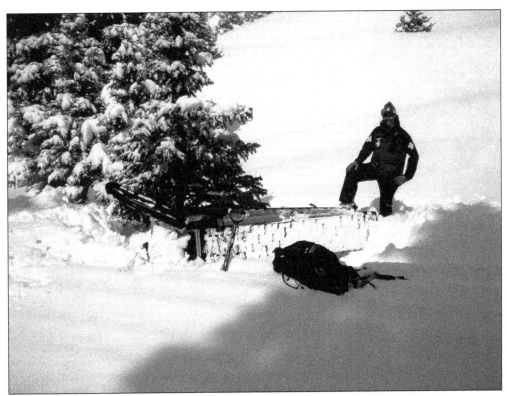

**REMEMBERING DRE.** Andre "Dre" Hartleif looks up while recovering a snowmobile he "parked" near a tree at Arapahoe Basin. Hartleif, a native of New Zealand, was living his dream as a ski bum while patrolling in 2011. On February 16, 2012, he was killed after being swept and buried in an avalanche while skiing with two friends on Wolf Creek Pass. As was customary, he and his friends decided who would go first by a game of rock-paper-scissors. Dre went first. He looked back and said, "See you at the bottom." (Courtesy of Arapahoe Basin Ski Patrol.)

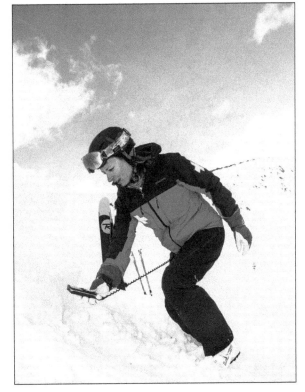

**BEACON SEARCH.** Angie Ward, a patroller at Aspen Highlands since 2008, demonstrates a fine transceiver search during avalanche training at the Mary Jane side of Winter Park in 2015. All patrollers carry avalanche transceivers and routinely practice search techniques. (Courtesy of National Ski Patrol.)

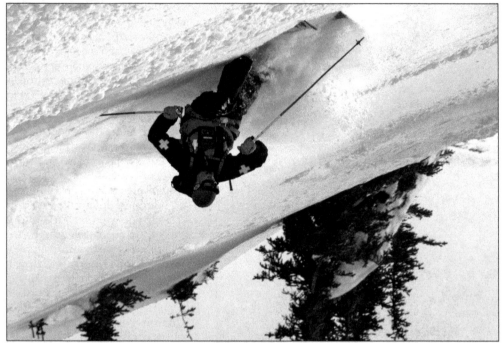

**Tony Cammarata.** Tony Cammarata, director of Arapahoe Basin Ski Patrol, is in his element while skiing a slalom slope early in the season in 2011. (Courtesy of Arapahoe Basin Ski Patrol.)

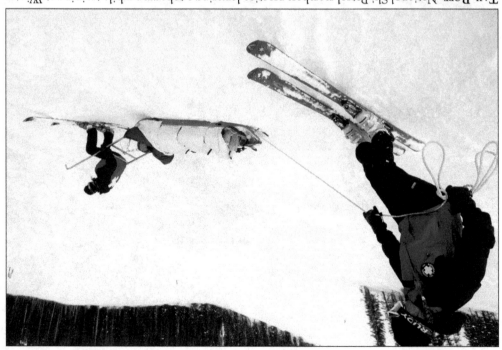

**Tail Rope.** National Ski Patrol members practice lowering a toboggan while training at Winter Park Resort in 2015. The toboggan is the most efficient way to transport a patient through steep, snow-covered terrain. While toboggan styles differ slightly, the most important rule when using one is "never let go." (Courtesy of National Ski Patrol.)

# *Three*

# ADVANCED MOUNTAIN RESCUE

The many advancements in technology that have made ski patrolling safer have also made the job more complex.

From strong yet releasable bindings, to the latest avalanche transceivers, to inflatable flotation packs, technology has allowed patrollers in Colorado to do their jobs more safely than their predecessors. Encountering and mitigating avalanche hazards within the ski area boundary is part of a patroller's job, but the potential for serious injury or worse remains.

Colorado is the state with the highest number of avalanche-related fatalities, with 275 since 1951. Avalanches are an inherent risk of skiing.

To best respond to an avalanche, patrollers train with special equipment. Patrollers often (if not always) carry avalanche transceivers, probes, and shovels. Beacon searches, refined probing, and shoveling techniques offer the best chance of survival for someone buried by an avalanche.

Another tool available to patrollers is trained rescue dogs. They often become the unofficial mascots of patrol and excel in their unmatched ability to locate a person buried in avalanche debris by scent.

Patrollers use all these tools, along with proficiency on high-angle rescue and weather and avalanche forecasting, to help ensure the safety of everyone on the mountain.

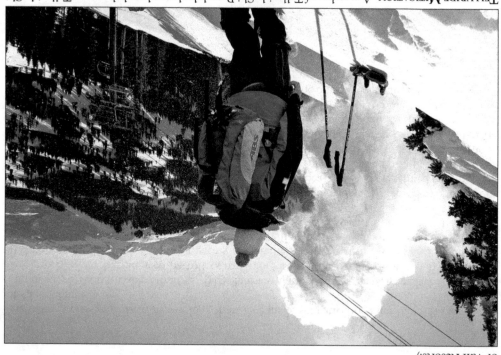

**TELLURIDE MITIGATION.** A member of Telluride Ski Patrol deploys a hand charge at Telluride Ski Resort around 2013. Explosives are closely monitored by the state and federal government. Each patroller is required to undergo specialized training and background checks and pass a written exam in order to become a permitted handler. (Courtesy of Telluride Ski Resort.)

**SUNSET.** A patroller at Vail Mountain pauses to watch the sunset at the end of the day. (Courtesy of Vail Resorts.)

**AKJA.** A patroller with a toboggan called an akja is seen here at Vail Mountain in 2004. Once a patient is loaded, a second set of handles are installed for use by a second patroller during transport. (Courtesy of National Ski Patrol.)

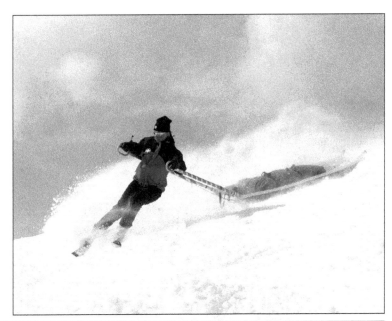

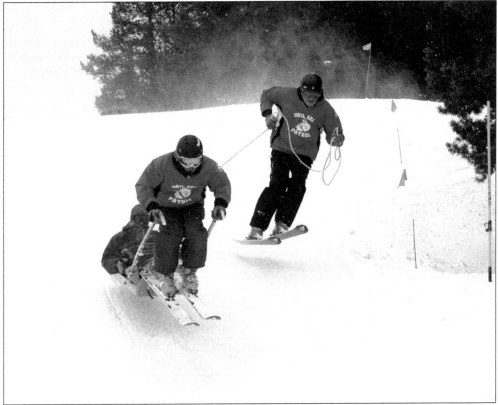

**TOBOGGAN RACES.** Vail patrollers race down a course during the much-anticipated toboggan races held during the 2014 patrol convention at Crested Butte Mountain Resort. The annual convention takes place every spring at a different ski area and brings patrollers from across the state. (Courtesy of National Ski Patrol.)

**SKI PATROL MAGAZINE.** Candace Horgan prepares a toboggan at Arapahoe Basin. This photograph was used on the cover of the fall 2016 issue of *Ski Patrol*. The quarterly magazine is published by the National Ski Patrol and has been in print since 1984. (Courtesy of National Ski Patrol.)

**TOBOGGAN DRIVING.** Patrollers at Arapahoe Basin drive a Cascade toboggan below the East Wall in 2015. The three dark spots in the snow high on the East Wall are remnants of explosive charges from earlier avalanche mitigation work. (Courtesy of National Ski Patrol.)

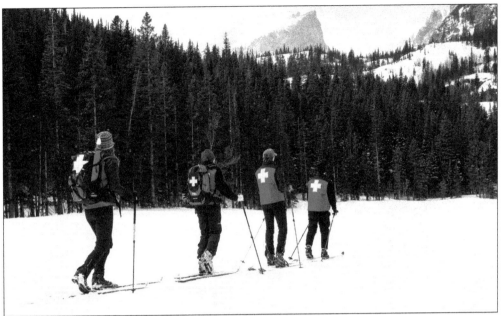

**NORDIC PATROL.** Members of the National Ski Patrol ski into Rocky Mountain National Park in 2016. That same year, the National Park Service and the National Ski Patrol formally signed a memorandum of understanding that will allow the NSP to conduct mutually beneficial search-and-rescue operations within the national parks. The agreement bolsters a long-standing partnership that has existed between the two agencies since 1938. (Courtesy of National Ski Patrol.)

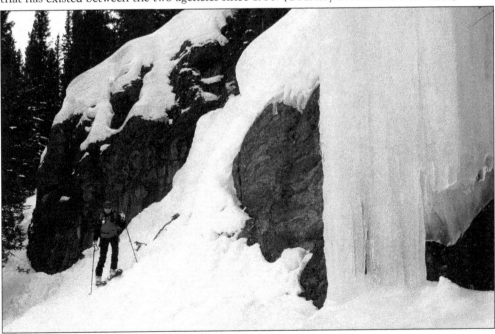

**PATROLLING THE PARK.** Nordic ski patrollers face different challenges than those common at alpine ski areas. Injured skiers can be miles from a trailhead, where extrication can be difficult and labor intensive. Here, a National Ski Patrol member skis beneath a frozen waterfall during a 2016 outing. (Courtesy of National Ski Patrol.)

**FIRST RESCUE DOG.** Avalanche rescue dogs are a critical part of search and rescue for many patrols in Colorado. When handler Chris "Mongo" Reeder brought Henry onto the Vail Mountain patrol in 2008, they set the track for the area's avalanche rescue dog program. For the dogs, every day is a training day. Whether they are practicing drills or riding chairlifts, like on this day in 2013, they are often the most beloved members of the patrol. (Courtesy of Vail Resorts.)

**IMPERIAL EXPRESS.** A Breckenridge ski patroller looks down Imperial Bowl under bluebird skies from the top of Peak 8 in 2013. The nearby chairlift, the Imperial Express SuperChair, installed in 2005, is the highest chairlift in North America, topping out at 12,840 feet. The lift hoists skiers on a quick 2.7-minute ride to expert-level terrain. (Courtesy of Vail Resorts.)

SNOWBOARD PATROL. A snowboarder and member of the National Ski Patrol rides at Winter Park in 2017. The National Ski Patrol includes patrollers who use snowboards. Regardless of equipment used to travel on the mountain, all members of the NSP are trained to the same standards. (Courtesy of National Ski Patrol.)

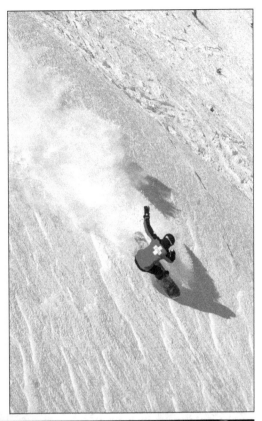

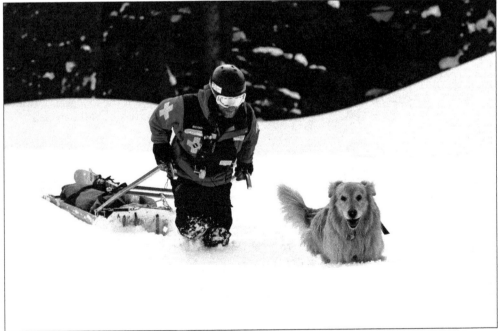

MONGO AND HENRY. Avalanche rescue dog Henry is often seen out on the hill while working at Vail Mountain. (Courtesy of Vail Resorts.)

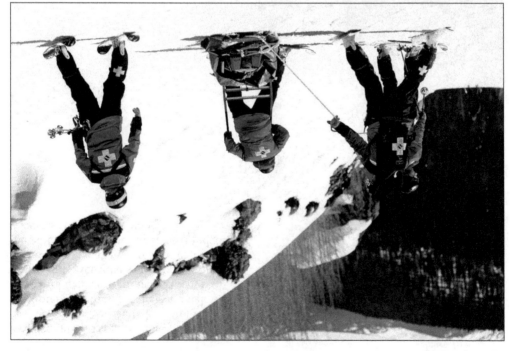

TOBOGGAN RESCUE. Vail patrollers transport a patient in a Cascade toboggan in 2013. One patroller "in the horns" steers the toboggan while a second "tail ropes" from behind. The tail roper can assist both with slowing the toboggan in steep terrain or accelerating it in flat terrain by using momentum to slingshot the toboggan forward. (Courtesy of Vail Resorts.)

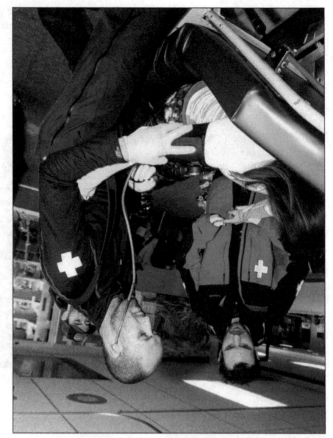

VITAL SIGNS. National Ski Patrol members take a round of vital signs from a patient. Many larger ski areas around Colorado have base clinics staffed with doctors who can see injured patients immediately when they arrive off the ski hill. (Courtesy of National Ski Patrol.)

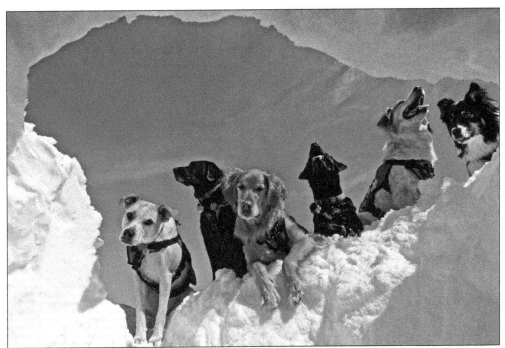

**AVALANCHE DOGS.** Breckenridge Ski Resort avalanche dogs look in for a photo opportunity in 2009. Ski patrols use dogs and their advanced sense of smell to assist rescuers as they recover people buried by avalanches. (Courtesy of Vail Resorts.)

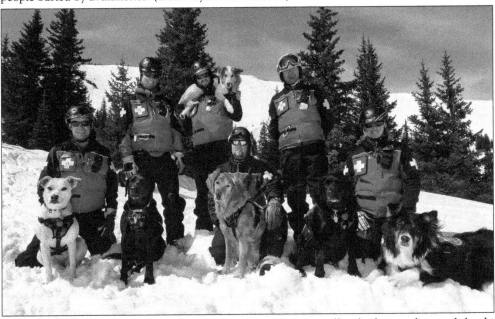

**DOGS AND HANDLERS, 2009.** Avalanche rescue dogs assist patrollers both in and around the ski area boundary. Breckenridge Ski Patrol partners with the Frisco-based Colorado Rapid Avalanche Deployment (C-RAD) program to make rescue teams available throughout the region. Each C-RAD team is made up of a rescue dog, dog handler, and avalanche technician that can be deployed by helicopter to avalanche sites when a rescue is needed. (Courtesy of Vail Resorts.)

**ANCHIN, 2016.** Rich Rogers and dog Anchin are part of a certified avalanche deployment team based at Monarch Mountain. Together with an avalanche technician, they are able to respond to incidents at Monarch Mountain and the surrounding mountains of central Colorado. (Courtesy of Monarch Mountain.)

**CHARGIN' CHARLIE.** Monarch Mountain patroller Charlie McGrail charges through deep snow in Monarch's Mirkwood Basin in 2016. (Courtesy of John Cameron.)

**NATIONAL SKI PATROLLER.** National Ski Patrol member Kara Flores is pictured at Arapahoe Basin on February 23, 2015. Among the roughly 30,000 members of the National Ski Patrol, which includes both volunteer and professional patrollers, the demographic breaks down to 79 percent men and 21 percent women. (Courtesy of National Ski Patrol.)

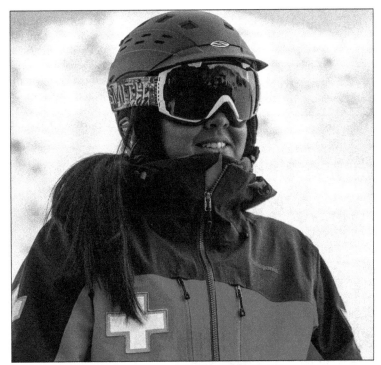

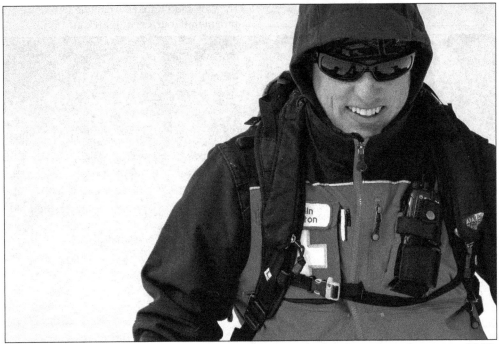

**COLIN SUTTON.** Sutton began skiing at Wolf Creek Ski Area when he was just three years old. He later returned to join Wolf Creek Ski Patrol, where he worked for 12 years, becoming the area's director of snow safety. On March 4, 2014, while making snow observations in a backcountry area near the resort, he was struck and killed by an avalanche. He was 38. (Courtesy of Wolf Creek Ski Area.)

**COLIN AND BOCA.** Colin Sutton was an accomplished member of the Wolf Creek Ski Patrol. He was a member of the National Ski Patrol and, in addition to numerous medical and avalanche certifications, was also a member of the C-RAD program and handler of his certified black lab Boca. (Courtesy of Wolf Creek Ski Area.)

**"LIFEGUARD TWO."** A pilot lands a Flight for Life helicopter atop Arapahoe Basin in 2018 during a training exercise. Air ambulances are used to transport avalanche rescue teams and dogs to avalanche scenes throughout the region in partnership with the Colorado Rapid Avalanche Deployment program. (Courtesy of John Cameron.)

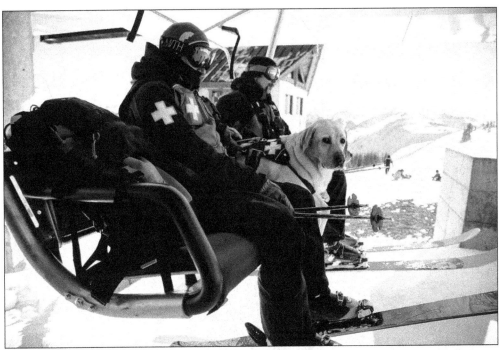

**WOLF CREEK.** Wolf Creek ski patrollers and an avalanche rescue dog ride a chairlift during the 2013 season. (Courtesy of Wolf Creek.)

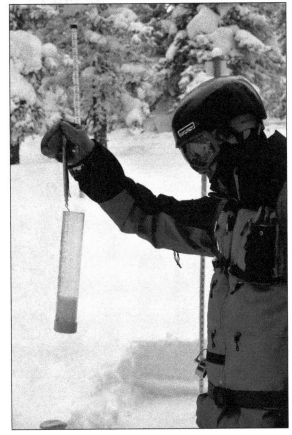

**SNOW STUDY.** Mike Colette measures the water content of a recent snowfall during the winter of 2015. Multiple observations are taken throughout each day at ski areas across the state to monitor the stability of the snowpack. Records at any given mountain can span decades and are used to compare seasons and observe long-term weather trends. (Courtesy of John Cameron.)

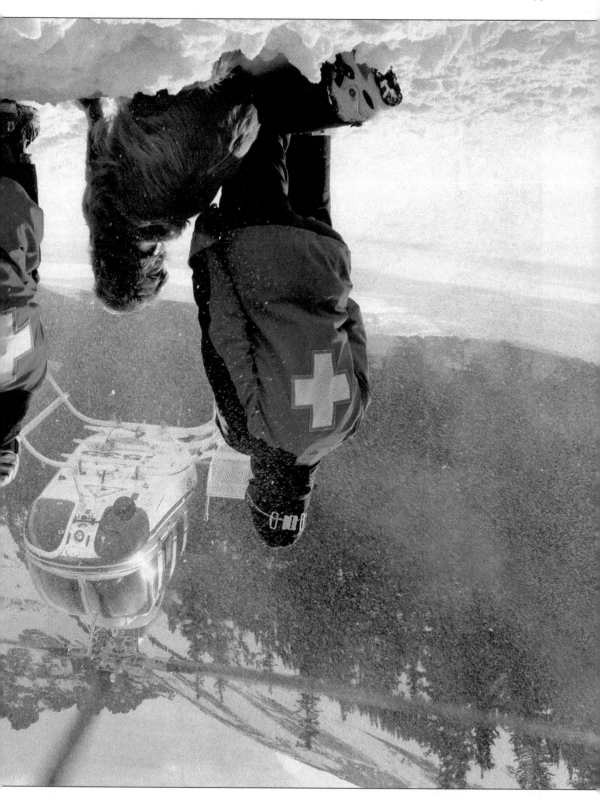

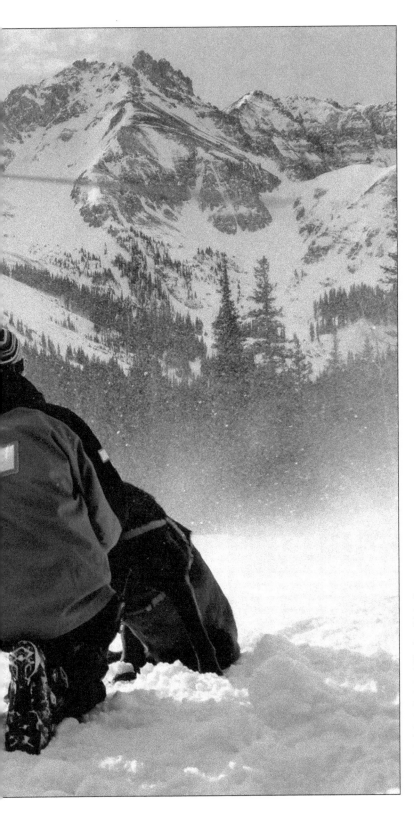

**TELLURIDE PATROL.**
Members of the
Telluride Ski Patrol
wait with their dogs
for a helicopter to
land around 2011.
Patrollers and their
dogs frequently train
to load and unload
helicopters to stay
proficient and ready for
avalanche deployment.
(Courtesy of Telluride
Ski Resort.)

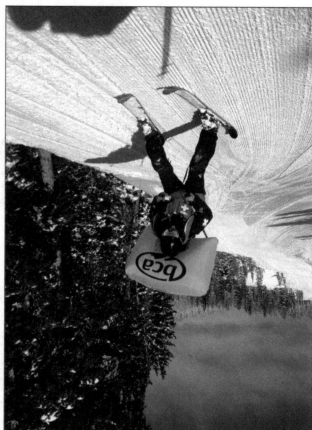

AIRBAG. A useful tool in hazardous terrain, airbag packs are often worn by patrollers conducting avalanche mitigation. The packs can be deployed with a handle on the shoulder strap if the skier is caught in a slide, and reduce their odds of being buried by the avalanche. Nick Sylvester was not caught in an avalanche; instead, his route partners thought it was pretty funny to pull his airbag handle as they skied by in 2015. (Courtesy of John Cameron.)

POWDER SKIING. Ben Ammon enjoys the perks of the trade during a 2016 ski lap through Mirkwood Trees at Monarch Mountain. (Courtesy of John Cameron.)

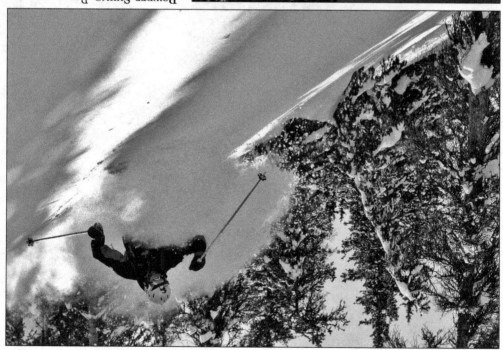

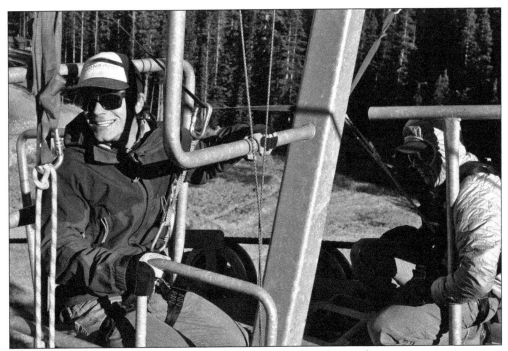

**FALL TRAINING.** Staying proficient with rescue skills needed during the winter requires training during the offseason. Patrollers begin their ski season even before the snow falls. Mike Collette and Dusty Reed practice high-angle rescue as they get reacquainted with the workings of a chairlift tower in 2016. (Courtesy of John Cameron.)

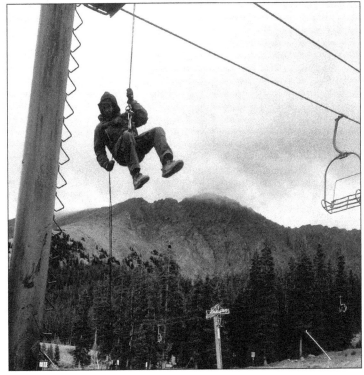

**SELF-EVAC.** Patrollers need to be able to assist guests in the event of a lift malfunction. To do that, they need to be on the ground. Carrying self-evacuation equipment allows patrollers to get themselves out of a chair should the need arise. To remain proficient, patroller Greg Dumas practices ahead of the 2017–2018 season at Arapahoe Basin during the annual fall refresher. (Courtesy of John Cameron.)

**SHUTDOWN.** Patroller Charlie McGrail skis under an empty chairlift. In December 2016, a storm brought so much snow to central Colorado that mountain roads and passes were choked to a halt. Monarch Mountain received over five feet of snow and was unable to open because the roads were impassable. Ski patrollers who had arrived early were escorted by highway crews to conduct avalanche mitigation in the area. (Courtesy of John Cameron.)

**WINDING DOWN.** As a friendly way to hold accountability among their coworkers, errors in workplace judgment are quickly made common knowledge. At Monarch Mountain in 2015, Norm Lastovica spins "the Wheel of Misfortune," which will determine the severity of his fine or the amount of beer he will owe the group. (Courtesy of John Cameron.)

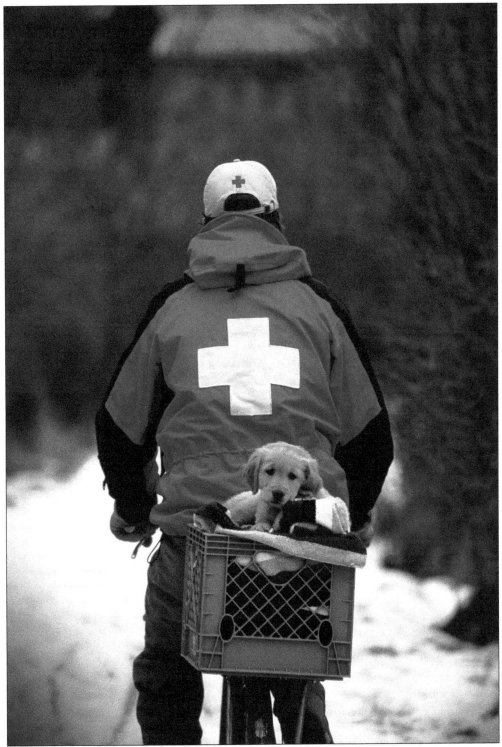

**JESSE.** A young avalanche dog rides home at the end of a long day. Jesse served as an avalanche rescue dog on Telluride Ski Patrol between 2001 and 2015. (Courtesy of Telluride Ski Resort.)

# DISCOVER THOUSANDS OF LOCAL HISTORY BOOKS
## FEATURING MILLIONS OF VINTAGE IMAGES

Arcadia Publishing, the leading local history publisher in the United States, is committed to making history accessible and meaningful through publishing books that celebrate and preserve the heritage of America's people and places.

Find more books like this at
**www.arcadiapublishing.com**

Search for your hometown history, your old stomping grounds, and even your favorite sports team.

CPSIA information can be obtained
at www.ICGtesting.com
Printed in the USA
LVHW060710301219
64204 0LV00004B/90/P